HOW TO DRAW AN ORC!

WRITTEN AND ILLUSTRATED BY TORIAN DEDMON, SR.

COPYRIGHT 2016 TORIAN DEDMON, SR. ALL RIGHTS RESERVED.

TABLE OF CONTENTS

Section 1
"Wire-framing" and rough layout

Section 2
Fleshing out the details

Section 3
Fine tuning and rendering

Section 4
Adding some personality to the character!

Section 5
Adding color

Section 6
Bonus Art!

1st Edition First Published 2016
Copyright 2016 by TJD Creative Media
All rights reserved. No part of this book may be reproduced or transmitted in any form or by any means, electronic or mechanical, including photocopying, recording or by any information storage and retrieval system, without written permission from the author, except for the inlcusion of brief quotations in a review.
The author and publisher of this book are providing it and contents on an "as is" basis and make no warranties on the contents, no warranty may be created or extended by sales representative or written sales materials.
This book has been created with the purpose of education and entertainment. The author and TJD Creative Media will have neither liability nor responsibility to any persons or entity with regards to any loss or damage caused, or alleged to have been caused, directly or indirectly, due to the information within this book.

INTRODUCTION

Welcome to my fantasy art drawing tutorial, "How to draw an Orc!" I am a huge fan of fantasy art and have enjoyed creating and drawing my own characters for as long as I can remember. If you're a fan of LORD OF THE RINGS, WORLD OF WARCRAFT or DUNGEONS AND DRAGONS, then this art tutorial is just for you! I take you from start to finish through my creative process. From the rough sketch phase to the final image, I explain the process that I use to create my character.

All vector artwork in this book was created using Adobe Illustrator CS3. The inking technique I prefer to use is a simple "draw and fill" method using the pen tool. I like to use thick, bold lines when I create my vector designs.

If you don't know how to use Adobe Illustrator or don't have digital art software training, you can still use this tutorial. All you will need is:
-a sketchbook (or blank white paper)
-pencil
-white eraser
-tracing paper

Other supplies that I use are Pigma Micron pens for inking detailed line work, SHARPIE black markers for filling in large areas and Copic Markers for coloring.

I've included a "wire-frame" page and a "low opacity" page in the Bonus Art section for you to print out and practice with. There is also a black and white coloring page!

I hope you enjoy this tutorial and would love to hear any feedback or comments that you may have. If you have an idea or a specific subject you would like me to create a drawing tutorial on, don't hesitate to reach out and let me know!

Thanks for your support!
Torian Dedmon,sr.

SECTION 1: "Wire-framing and rough layout

I first start by sketching a simple circle shape.

Next, I draw a horizontal line through the middle of my circle shape. This is will act as a guide that I'll use to place the eyes, ears and nose of my character.

I draw another vertical line down the center of my circle, directly intersecting my horizontal line. I make my vertical line much longer because it's going to act as a guide to help me establish my jaw line.

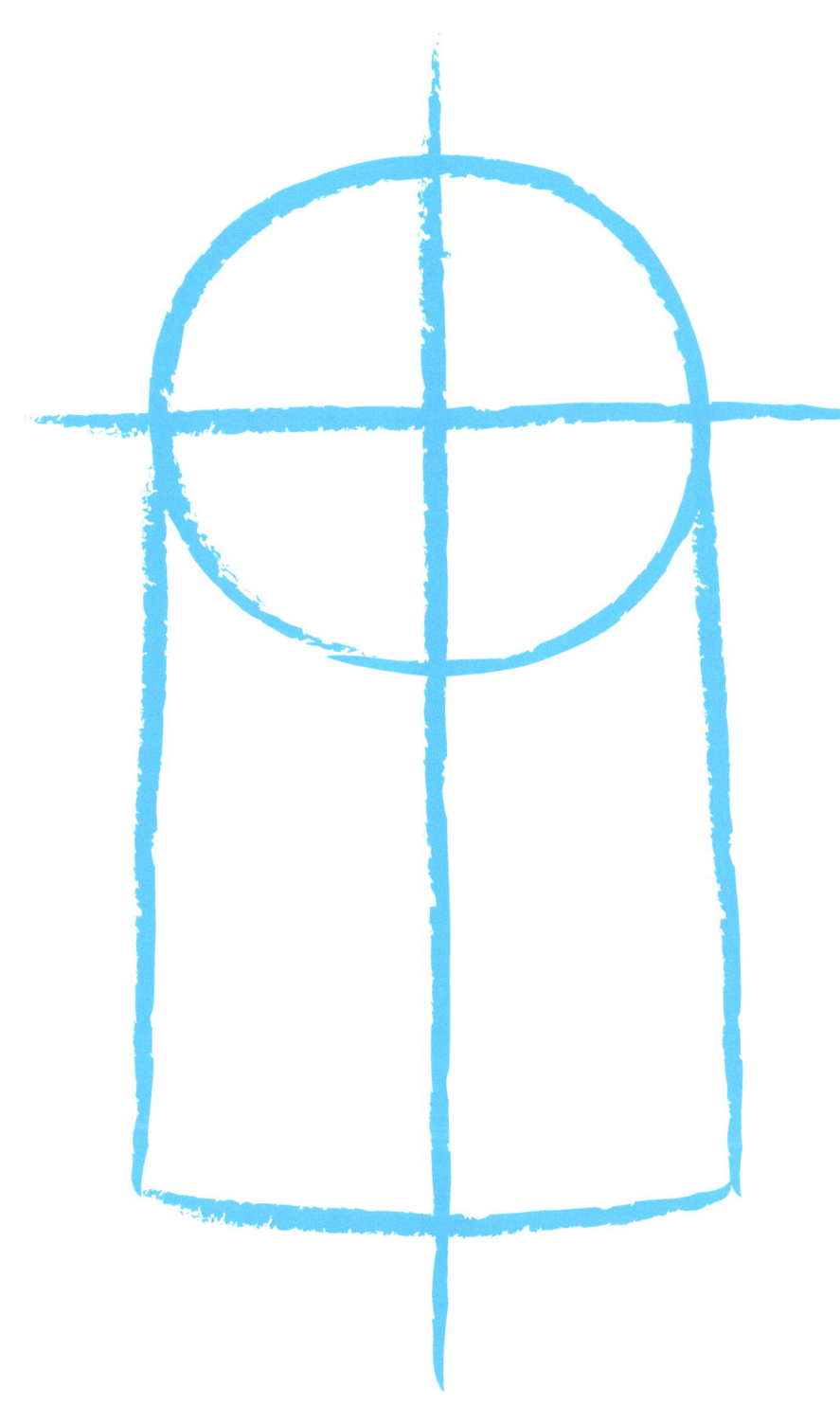

I draw my jaw line. Since orcs are very brutish and beast-like, I will be giving him a very large, oversized jaw.

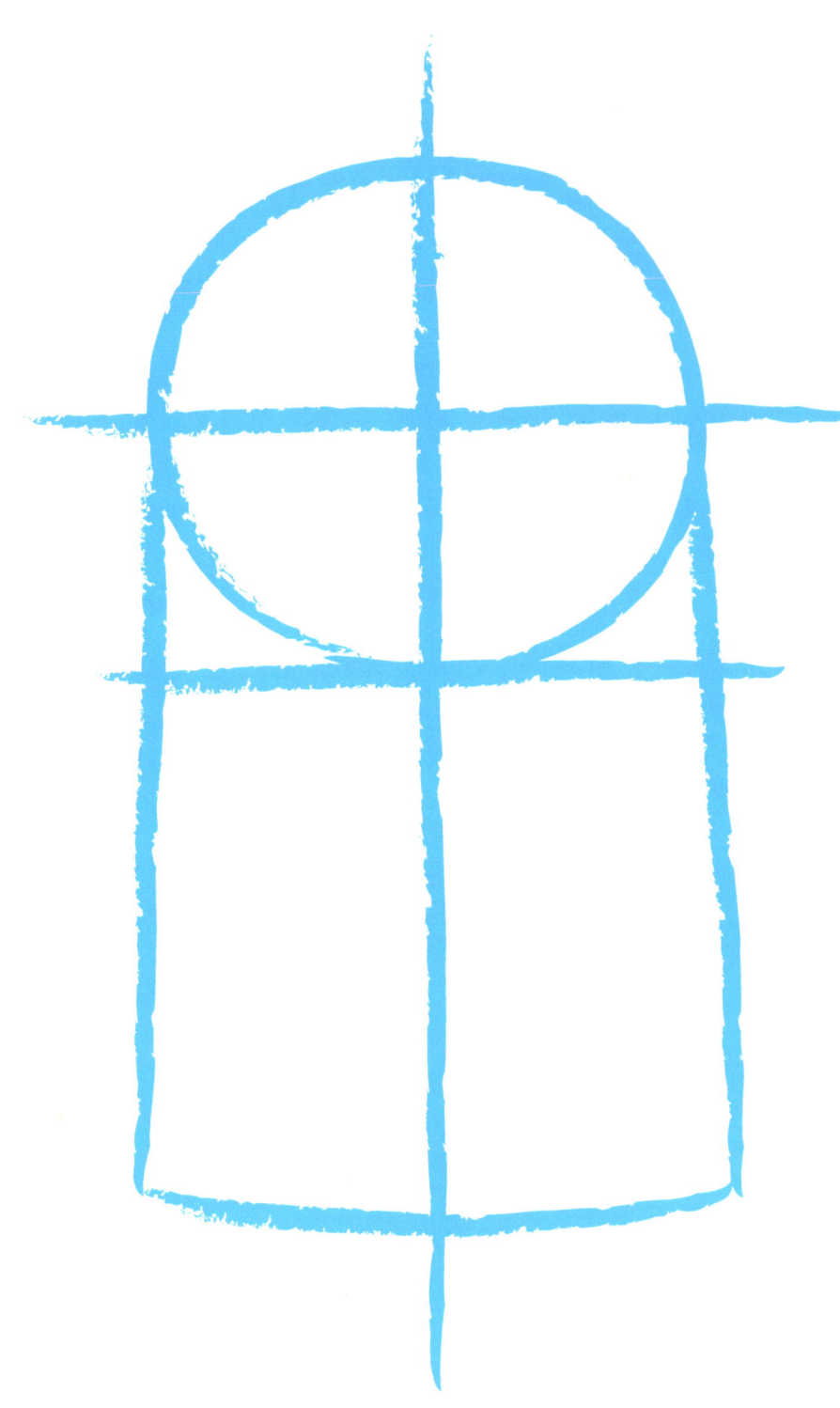

I add a second, smaller horizontal line that connects to the bottom of my circle shape. I'll use this line as a guide to where I want the bottom of my nose to be.

SECTION 2: Fleshing out the details

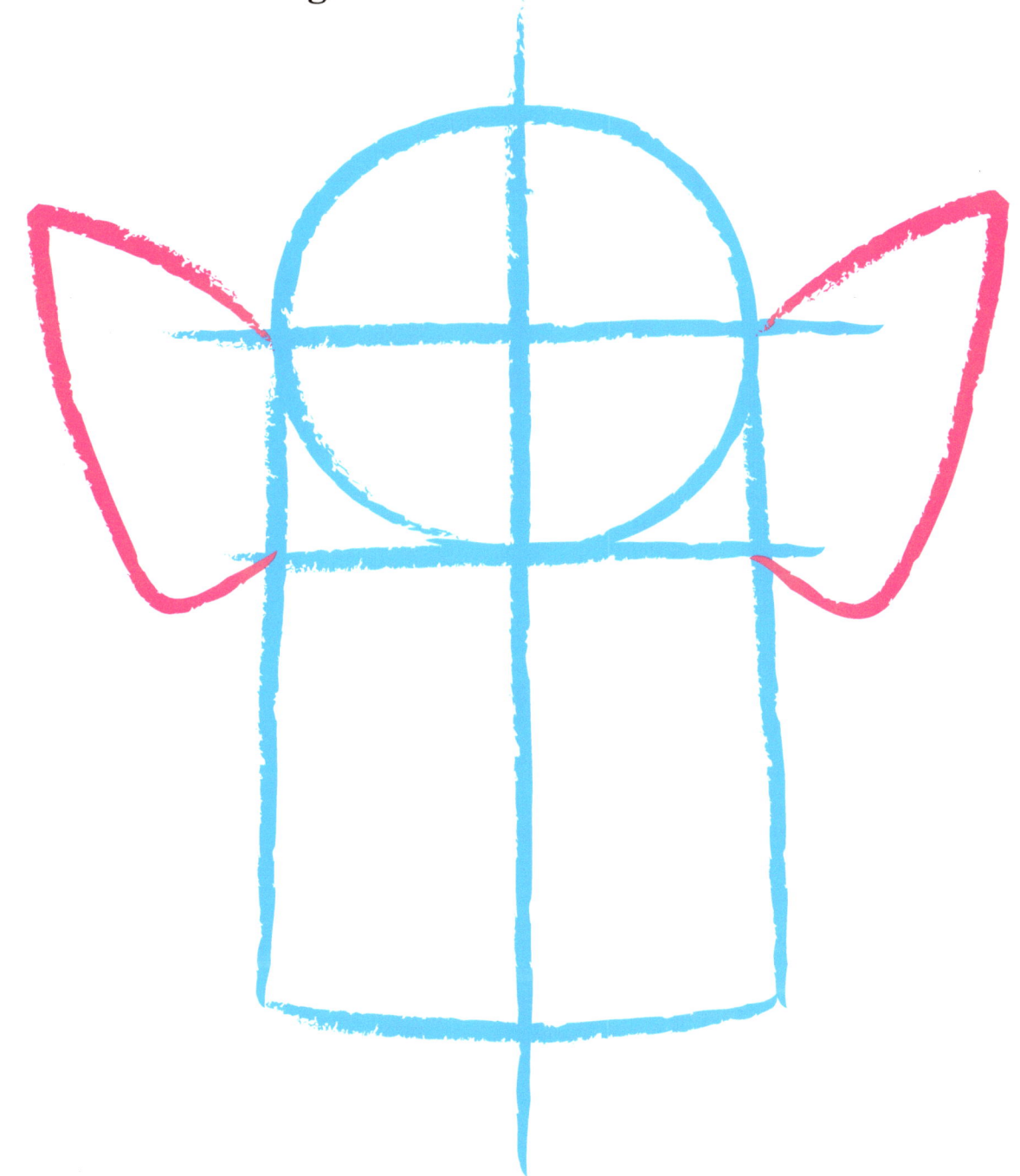

Now it's time to start adding some details! I start with creating the ears. I make the ears very large and pointed.
I use the eye and the nose lines as a guide to position where I want the ears to go.

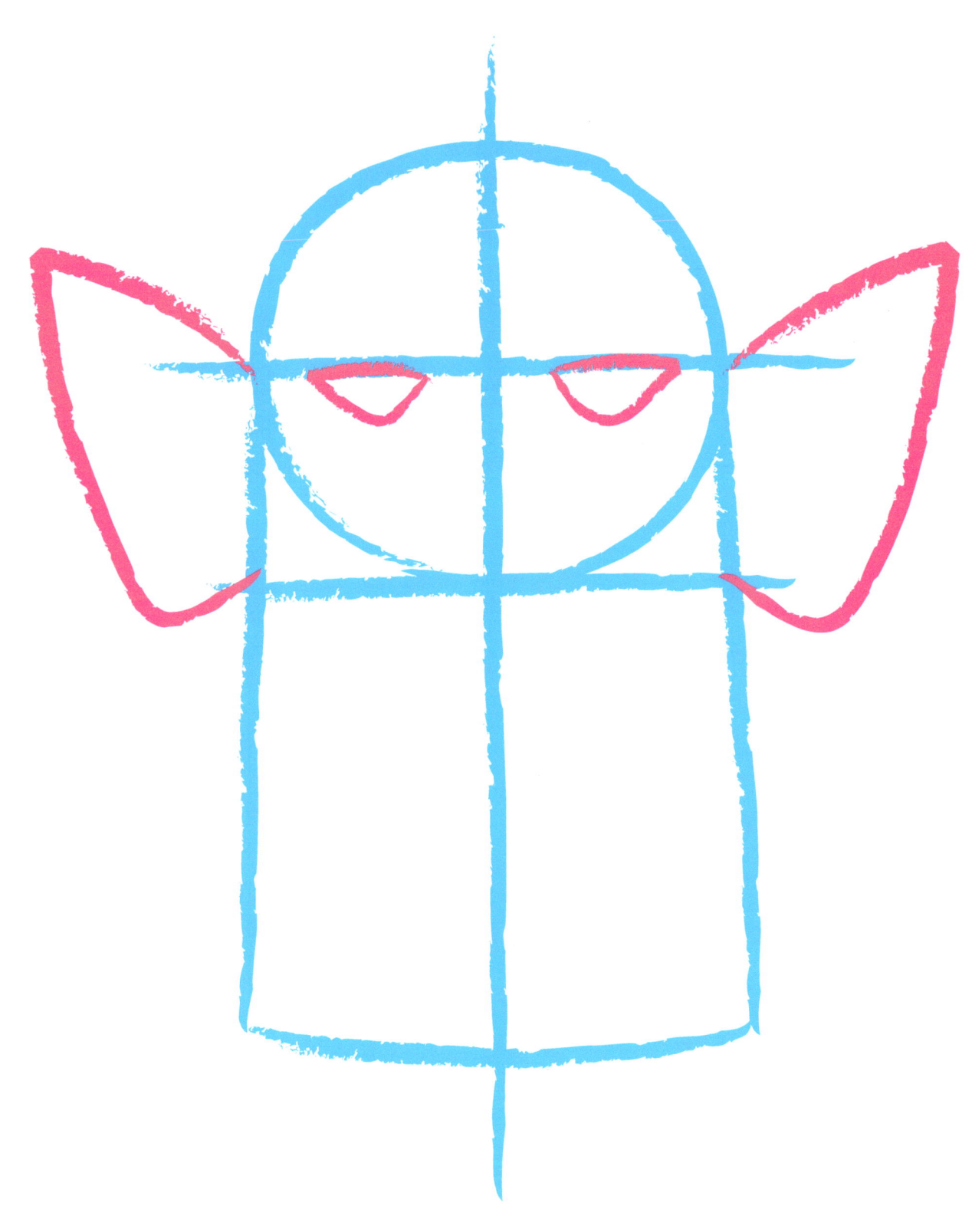

I draw some eyes. These are just simple, triangular shapes for right now.

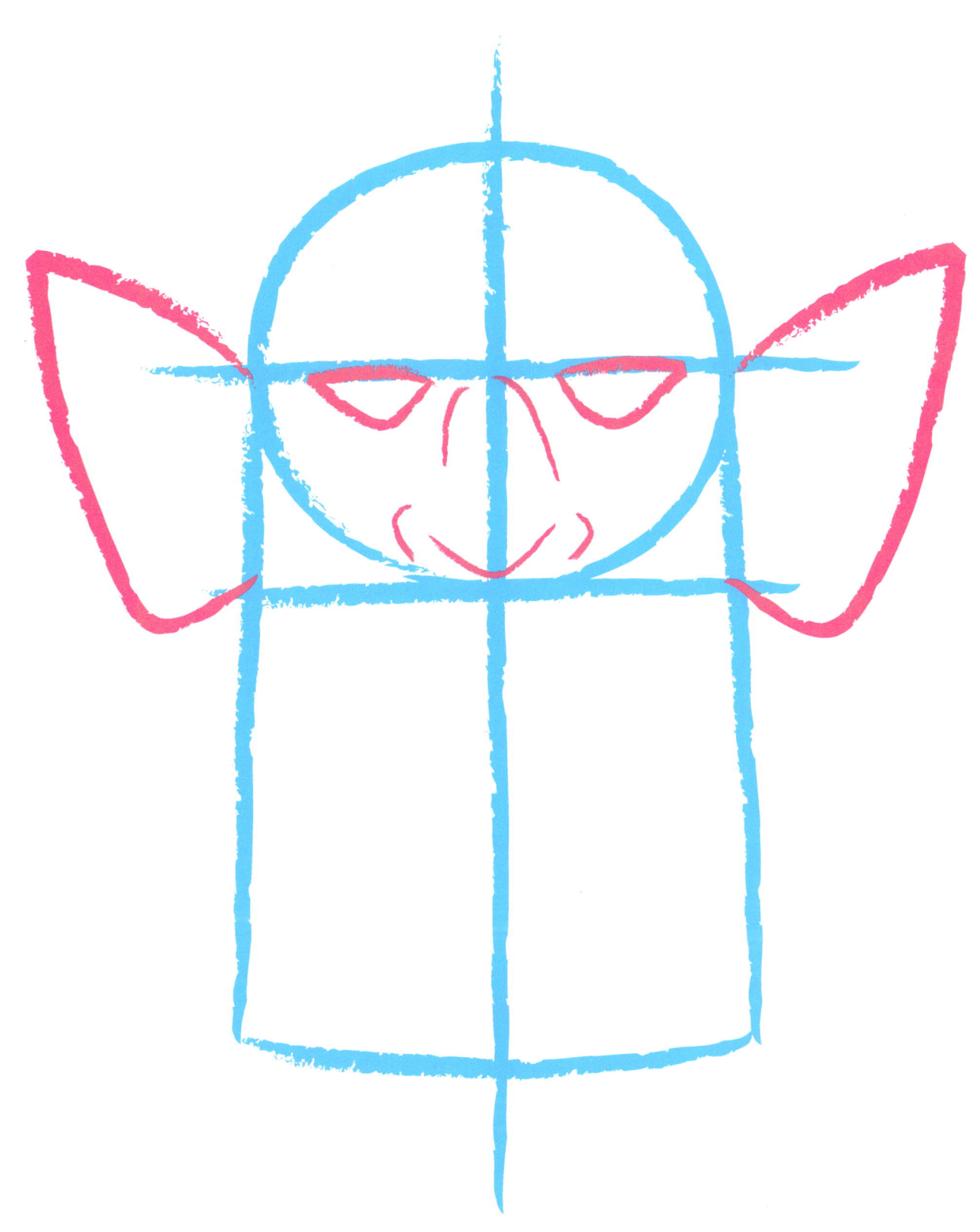

I'm ready to sketch in some lines for my nose.

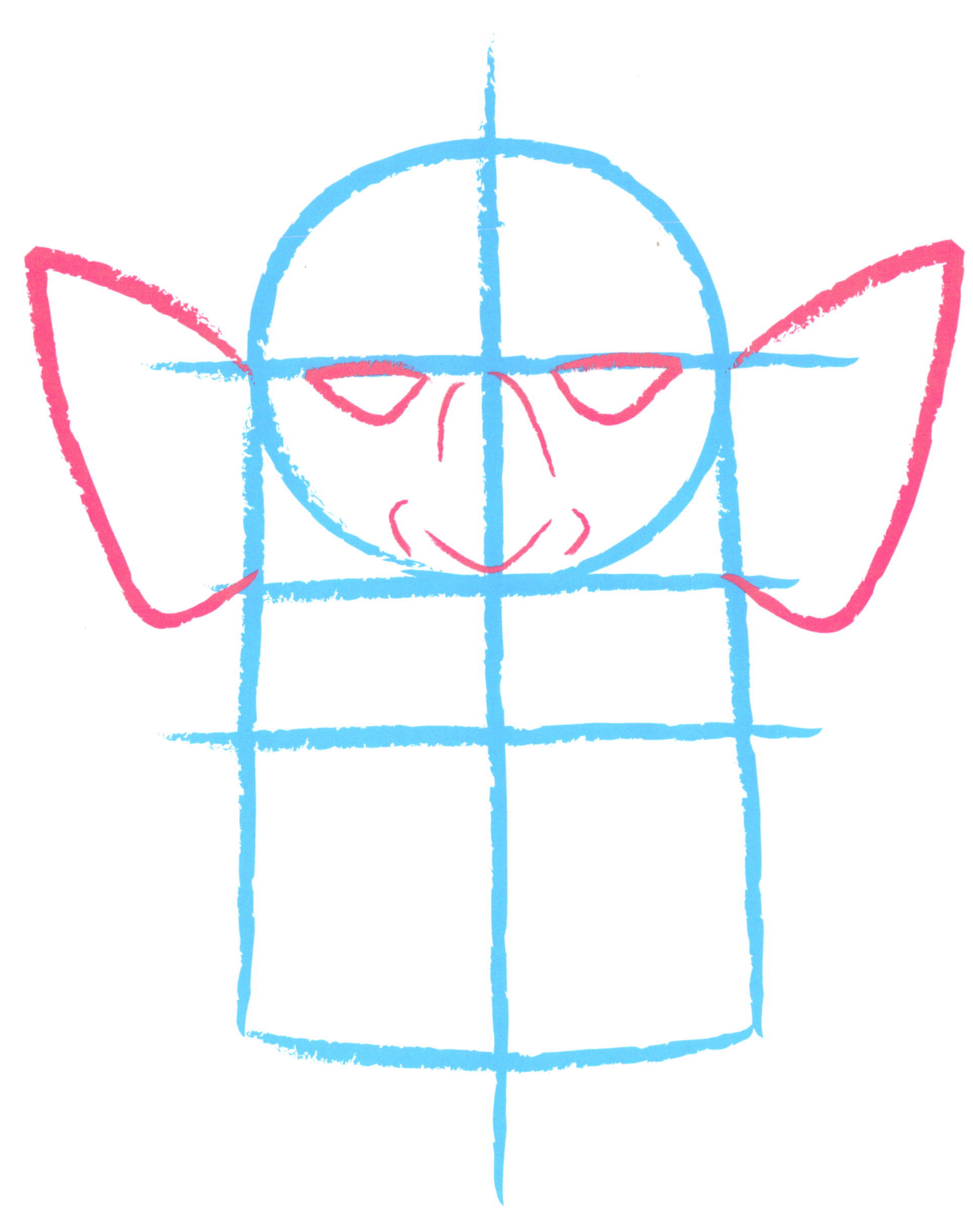

I draw a third horizontal line that will serve as a guide for the mouth.

SECTION 3: Fine-tuning and rendering

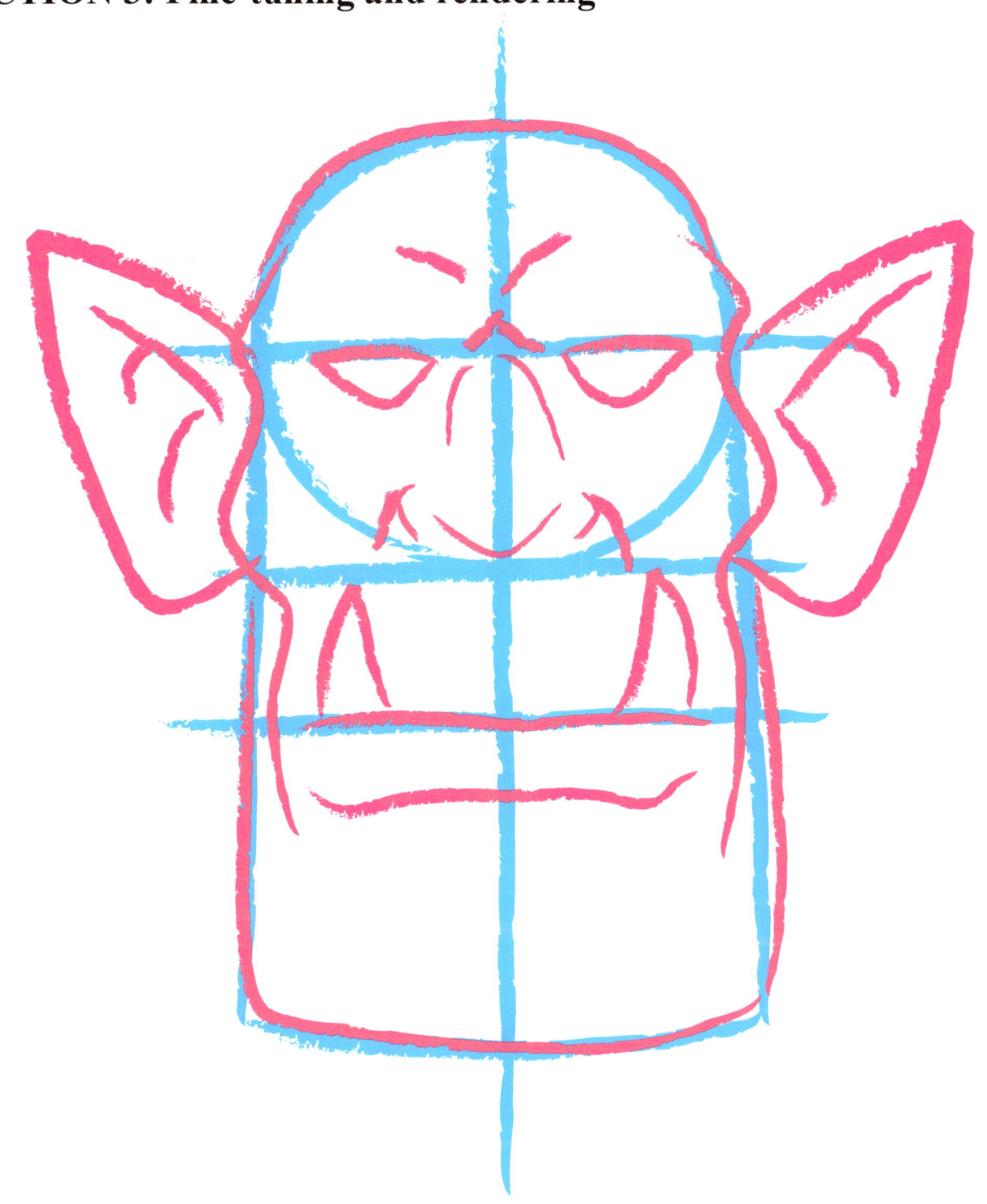

At this point, I lay down all of my rough line work, concentrating on making sure all the proportions and facial elements are how I want them. I don't worry about making things perfect because I'm going to tighten everything up when I do the ink work.

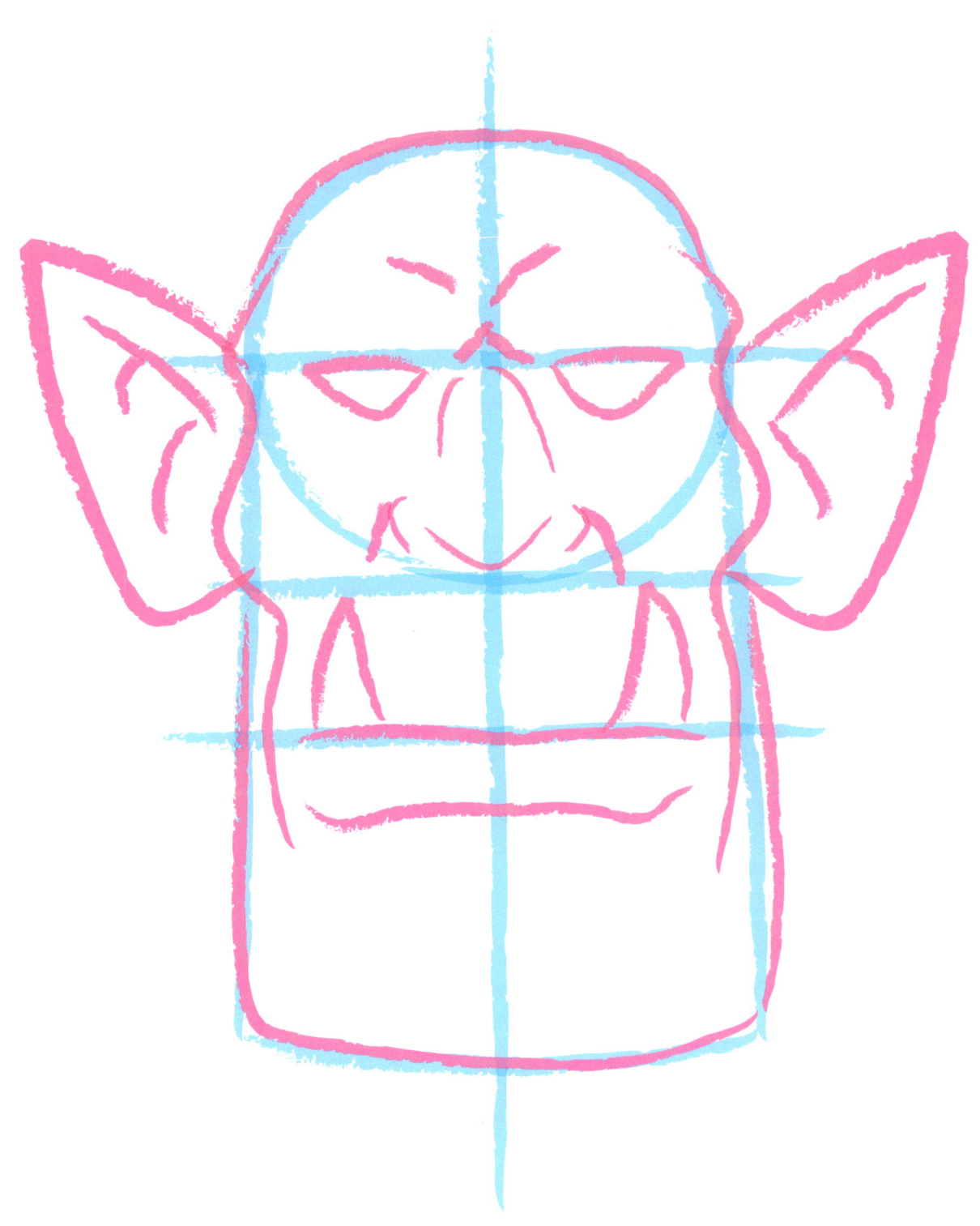

Since I'm working in Adobe Illustrator, I lower the opacity to about 50% so that I see just enough of the rough line art. I create another layer over this one. It will serve as my ink layer.

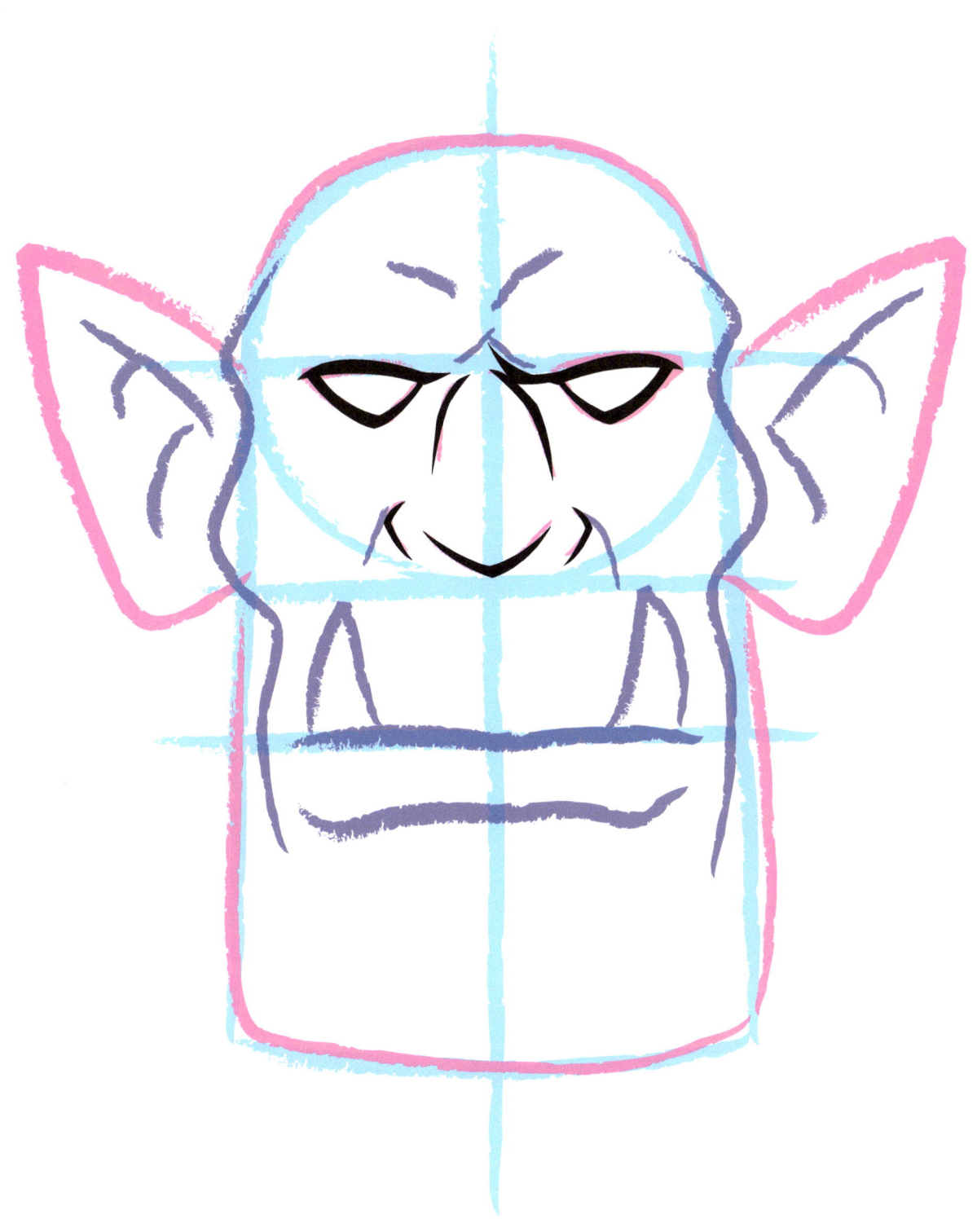

I start laying down my black ink lines using the pen tool. I always start with the eyes and nose, then go from there.

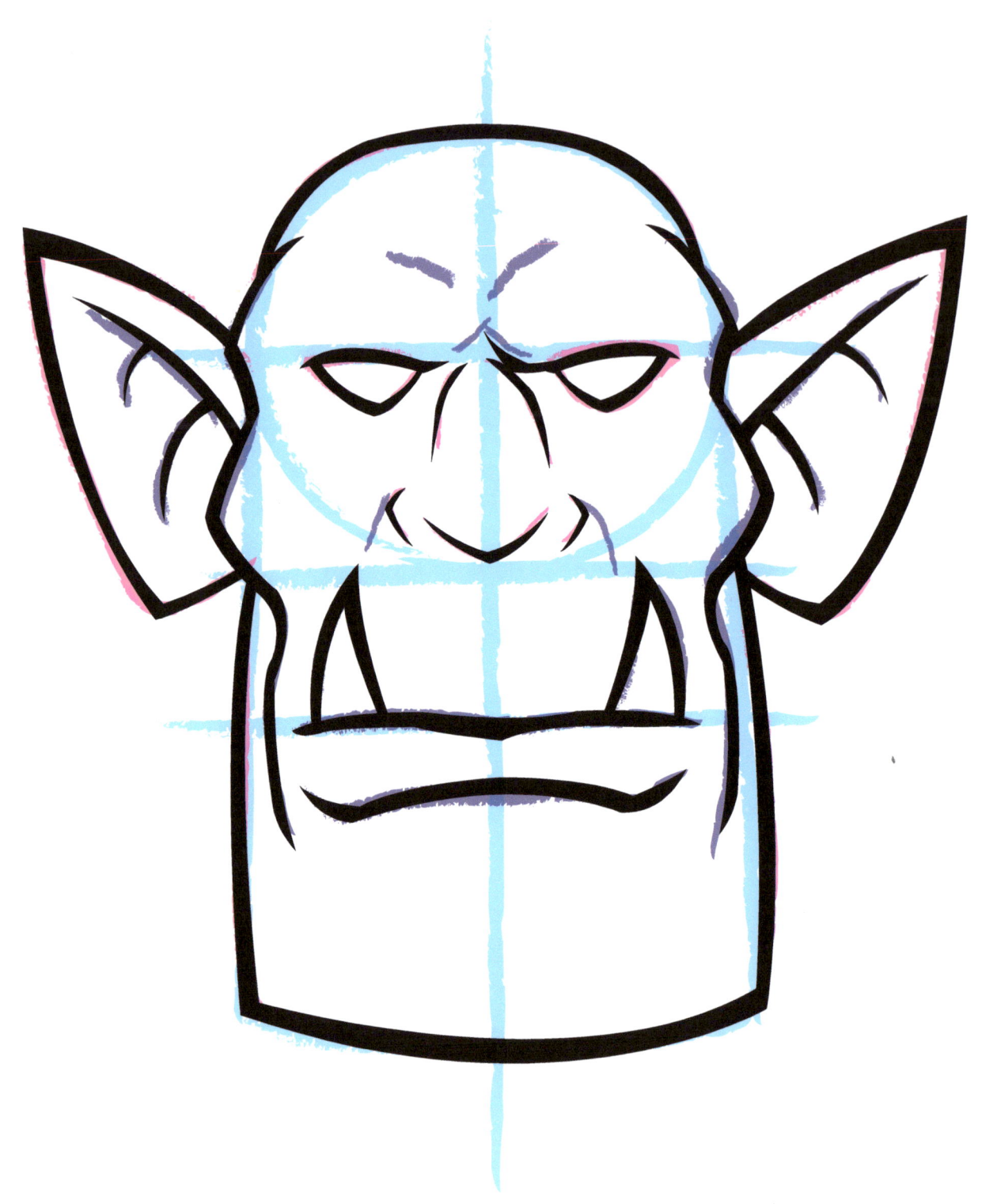

I quickly finish off the rest of the image. I take a moment to step back and evaluate my progress. At this point, I'm looking at how the facial features are placed and if I need to adjust some of my line work before I continue.

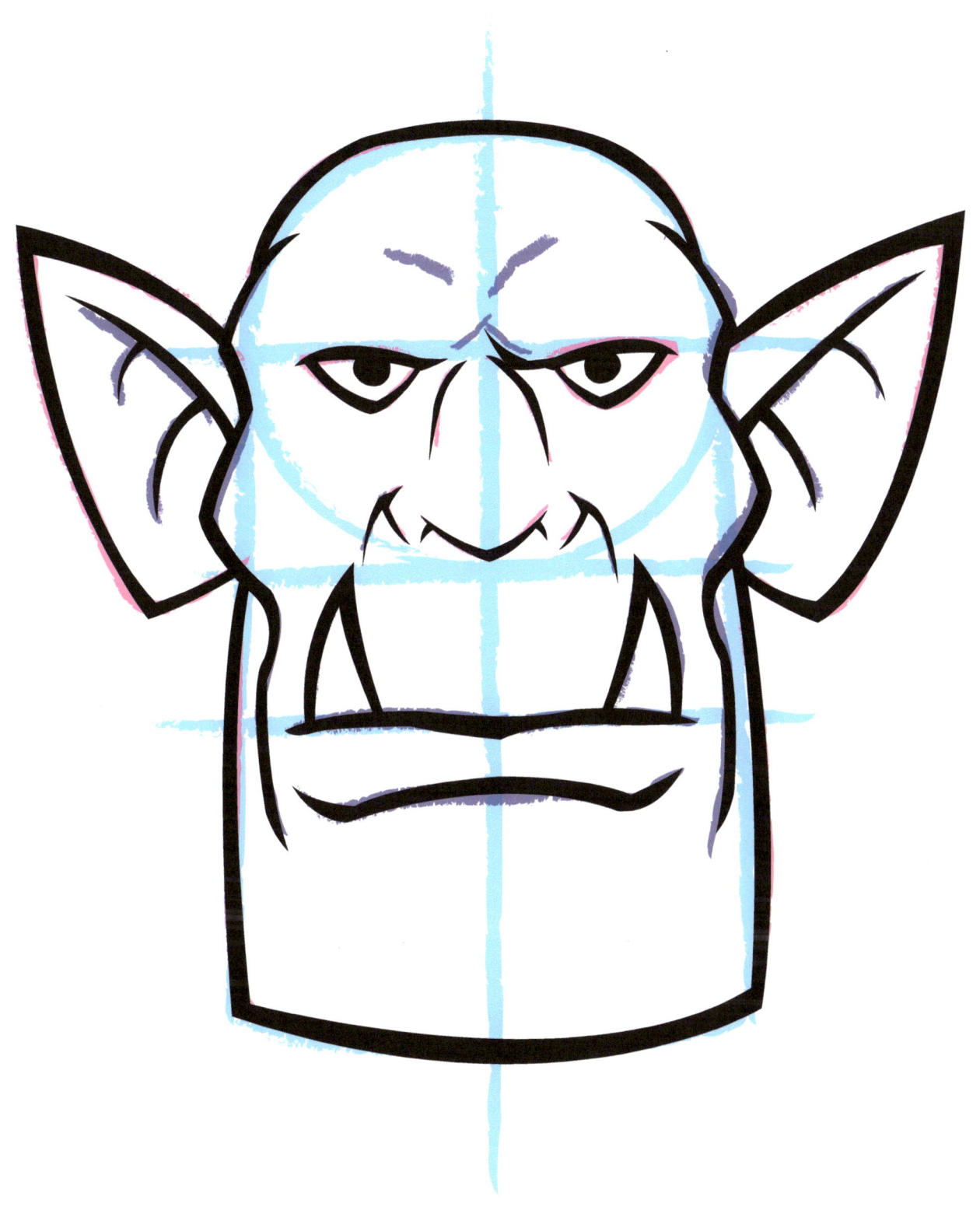

I add some pupils and some last minute line work around both nostrils.

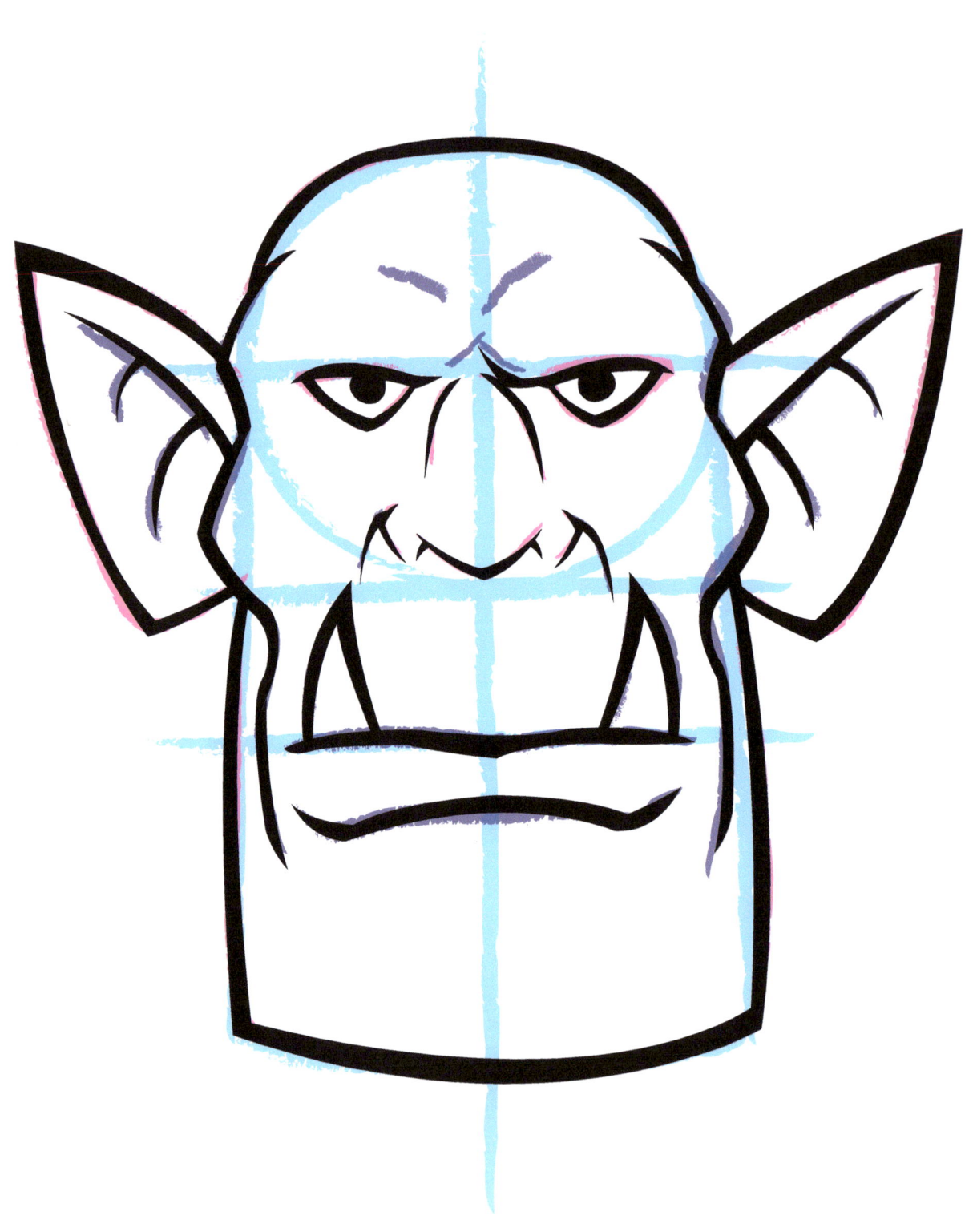

I look over the design once more to see where I need to add more line work and detail.

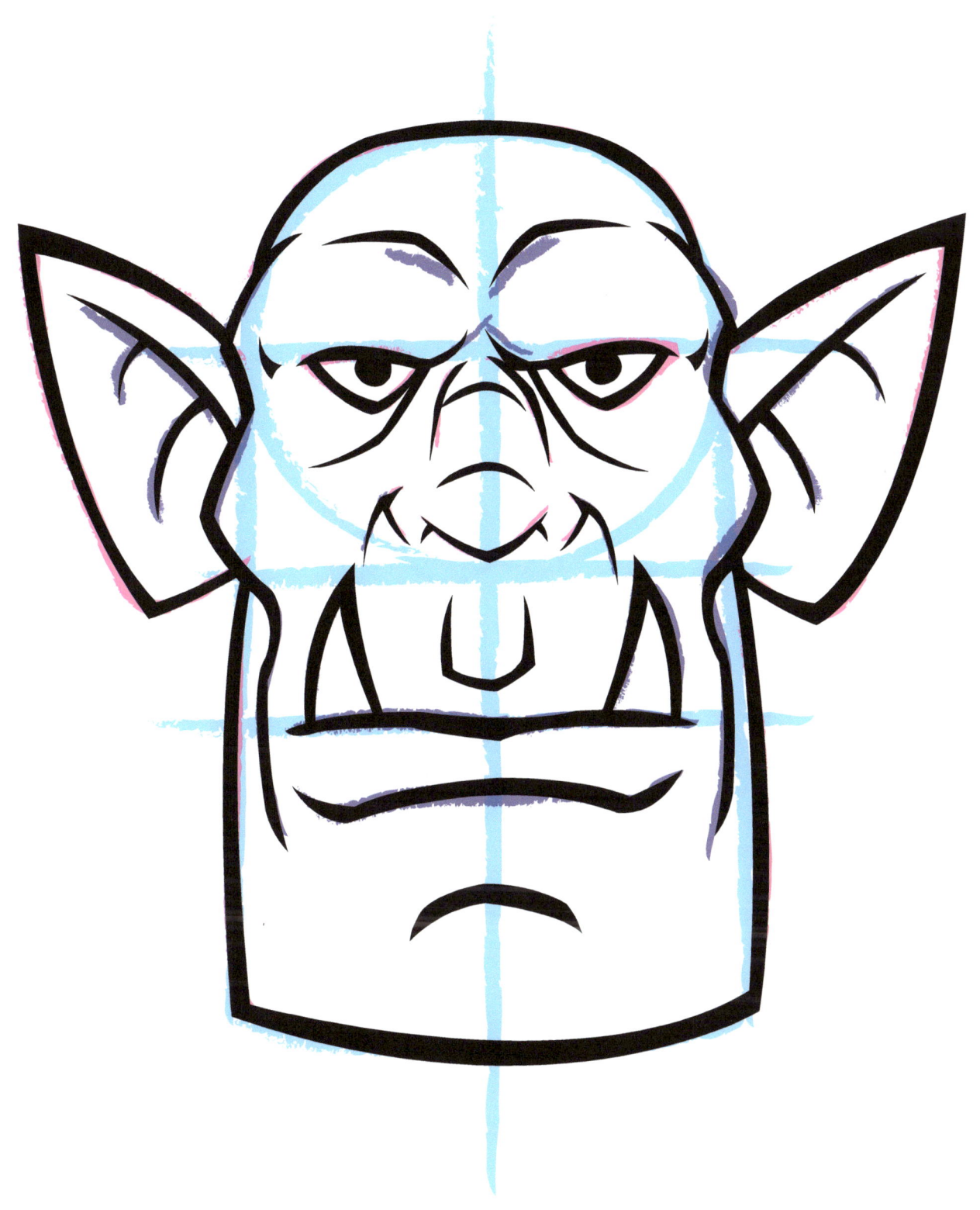

I add more line work to the eyebrows and around the eyes. I add some lines to the bridge of the nose. I put an upper-lip crease underneath his nose and a rounded, half-moon line shape to bring out his chin.

SECTION 4: Adding some personality to the character!

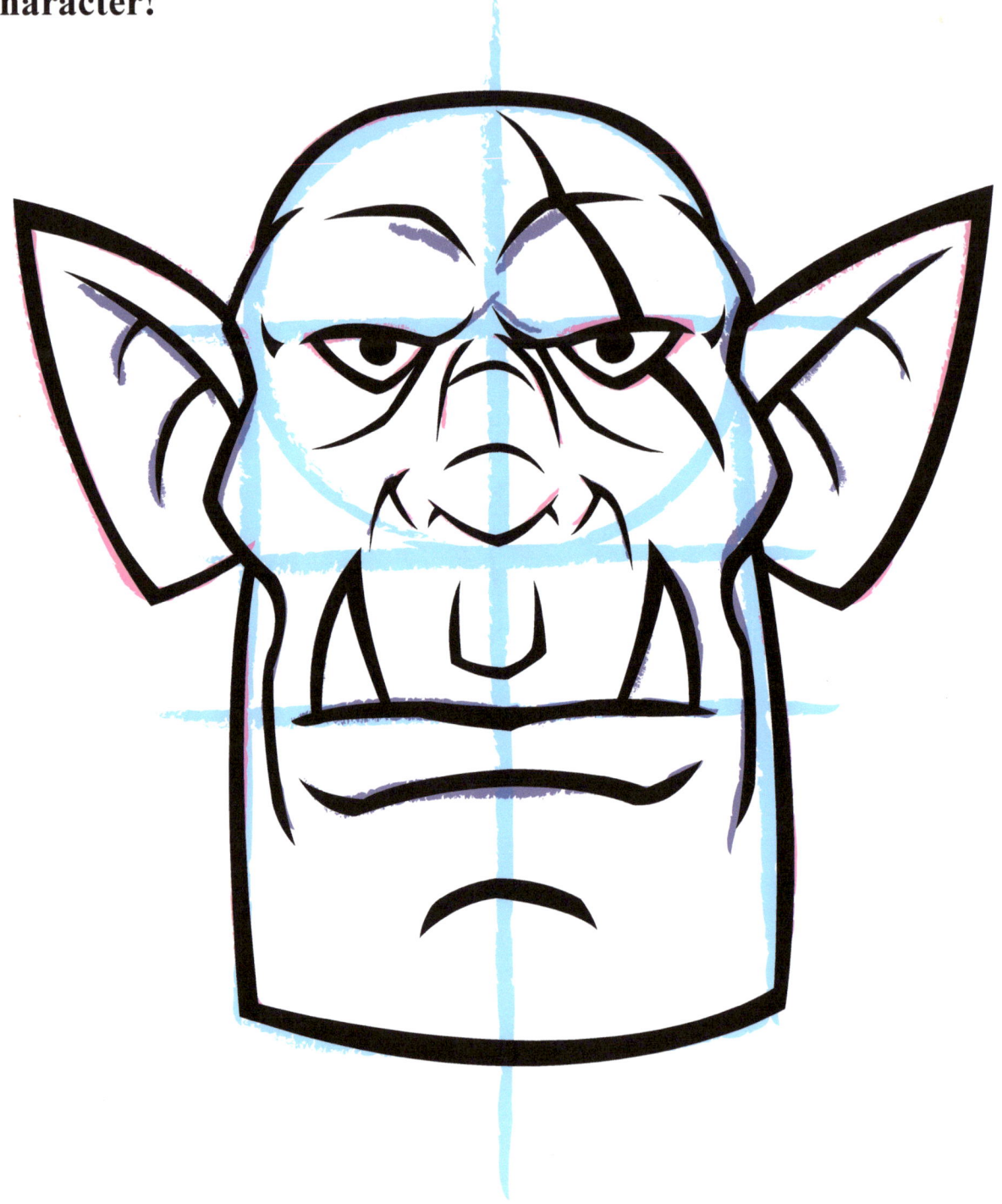

I want this character to have a lot of personality but I don't want to make the design too busy. I decide that I want to add a scar over one of his eyes. I start at the forehead and work my way down over his left eye, making sure to move with the contour of his face.

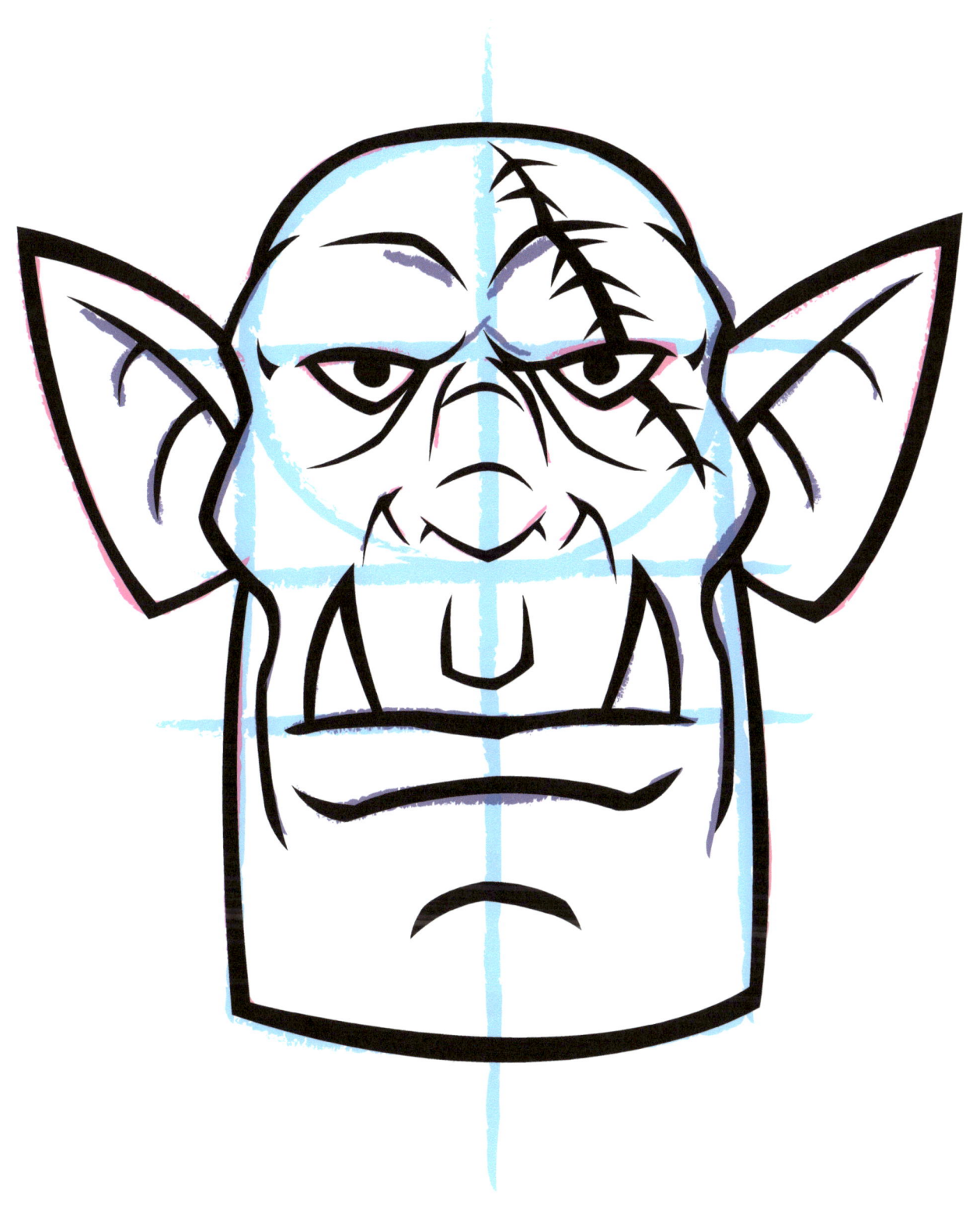

I create some "stitch" marks over the scar line and his facial scar is complete!

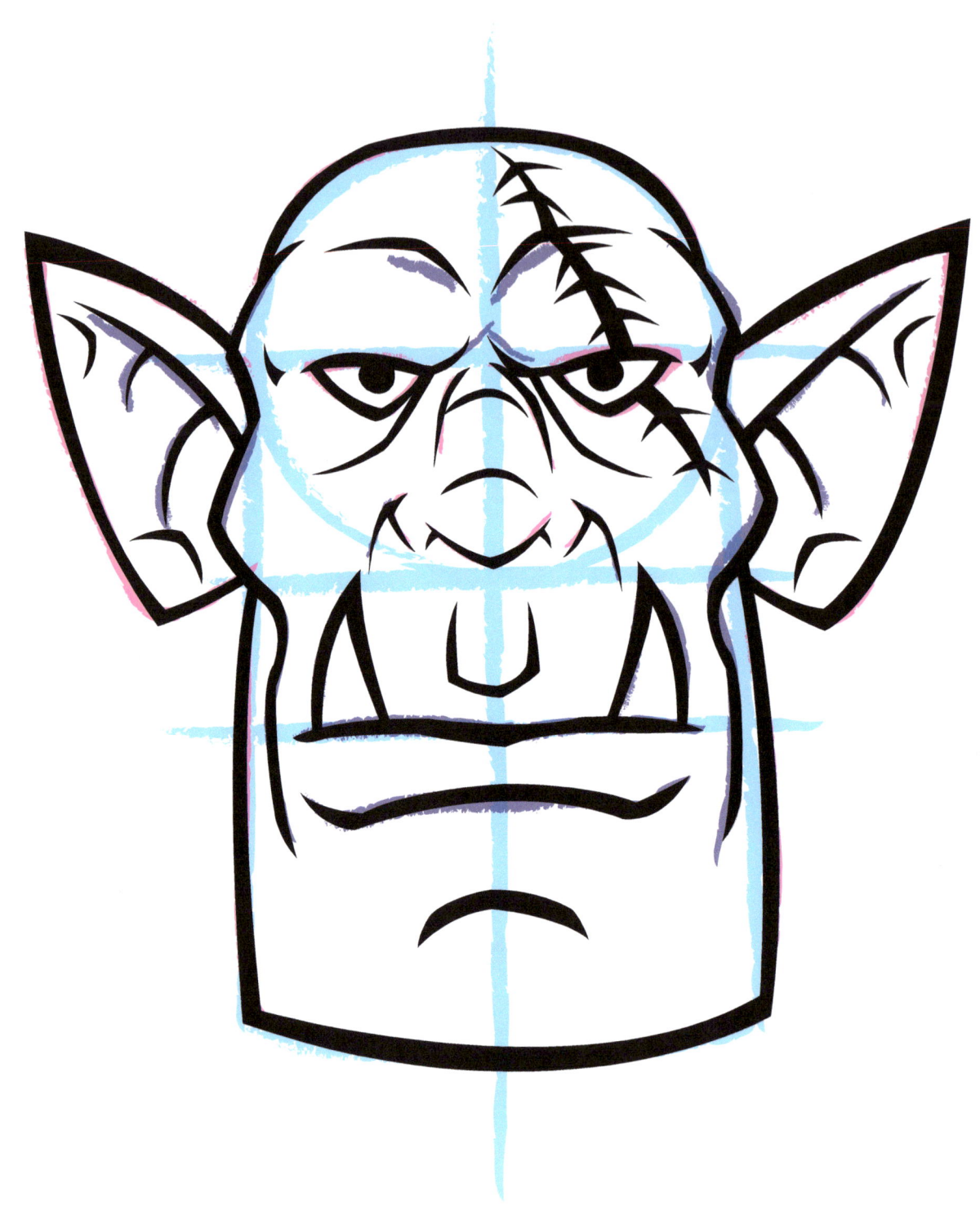

I decide to give my character some big loop-style earrings to complete his rugged, barbaric look. I start by creating four crescent-shaped objects that will serve as the openings that holds the earrings in his ears.

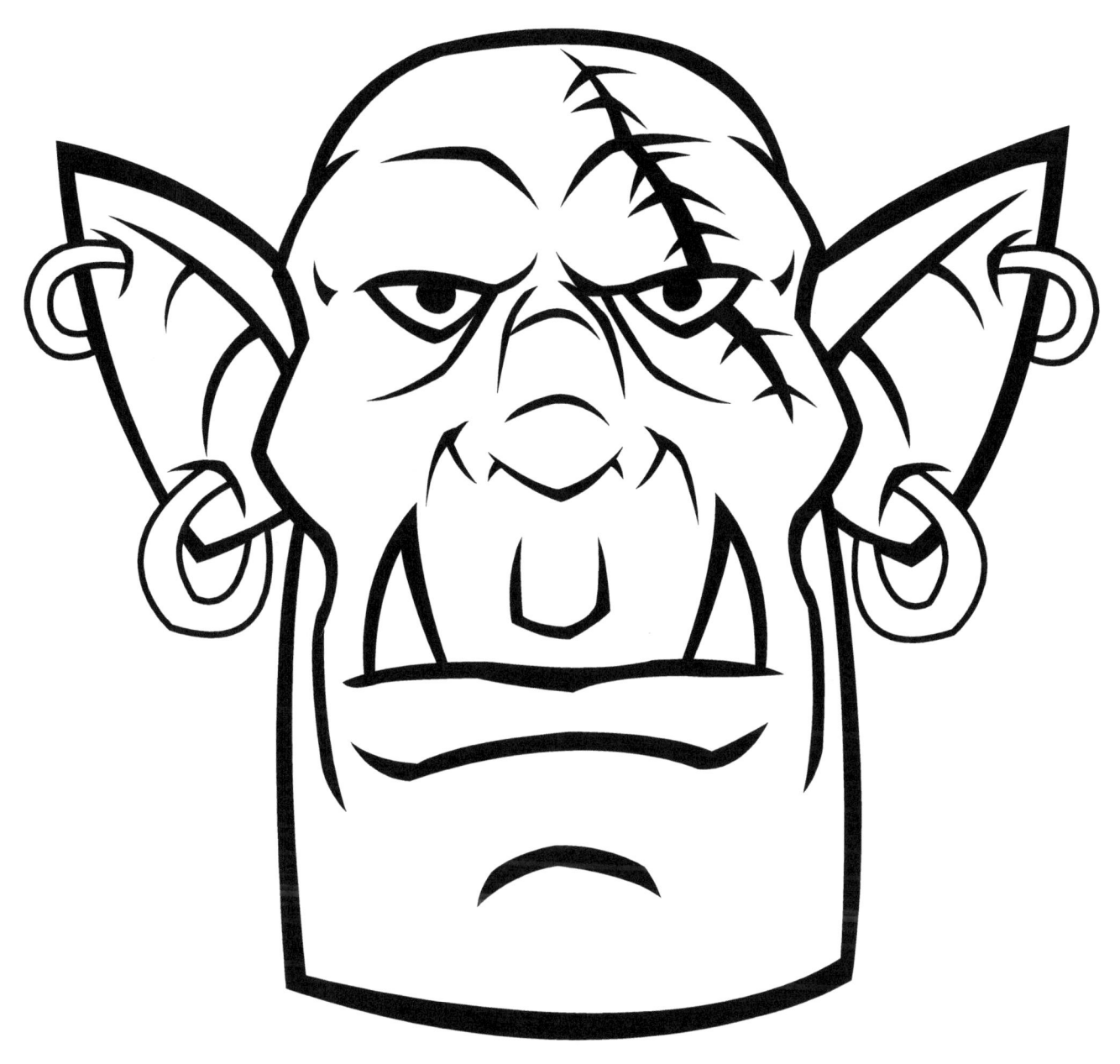

I draw some loop shapes to "fit" into the ears. My orc character design is now complete! I usually take a little time to look over the image to make sure that I'm totally happy with the finished product. Now that the inking is done, it's time to add some COLOR!

SECTION 5: Adding some color!

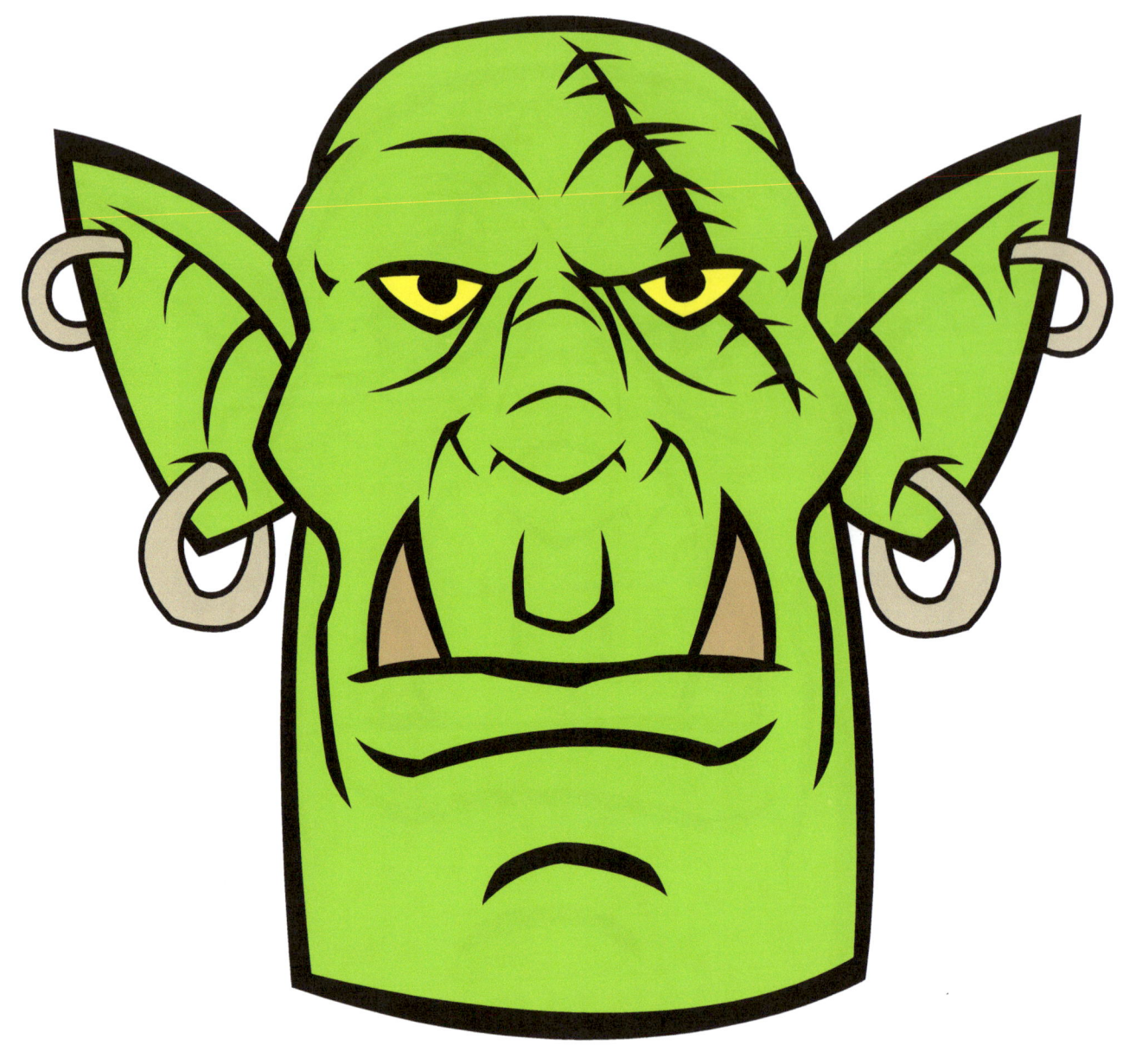

I import my finished inked image into photoshop to start adding some color. I create one layer for "flat" colors, and one more for what I call my "shadows" layer. I start by filling in all areas with a basic color. I look over the image to make sure I'm happy with all my color selections before saving the file and moving forward.

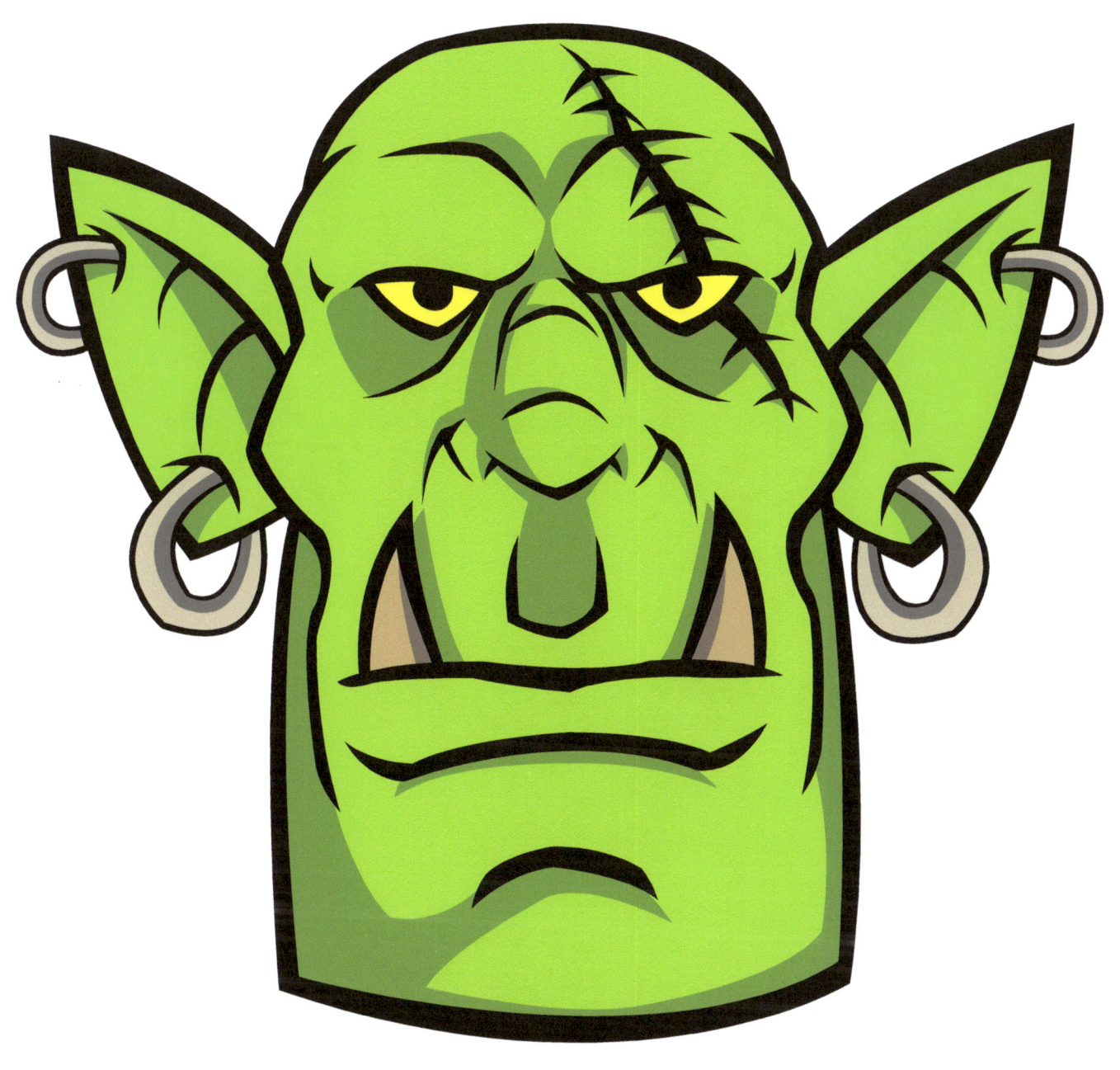

Once the flat colors have been put in, I switch to my "shadows" layer and add some darker color tones to create some dimension and depth to the character. Now my orc character is finished!

Use the pages in the **"Bonus Art"** section to practice the steps and create your own version!

SECTION 6: Bonus Art

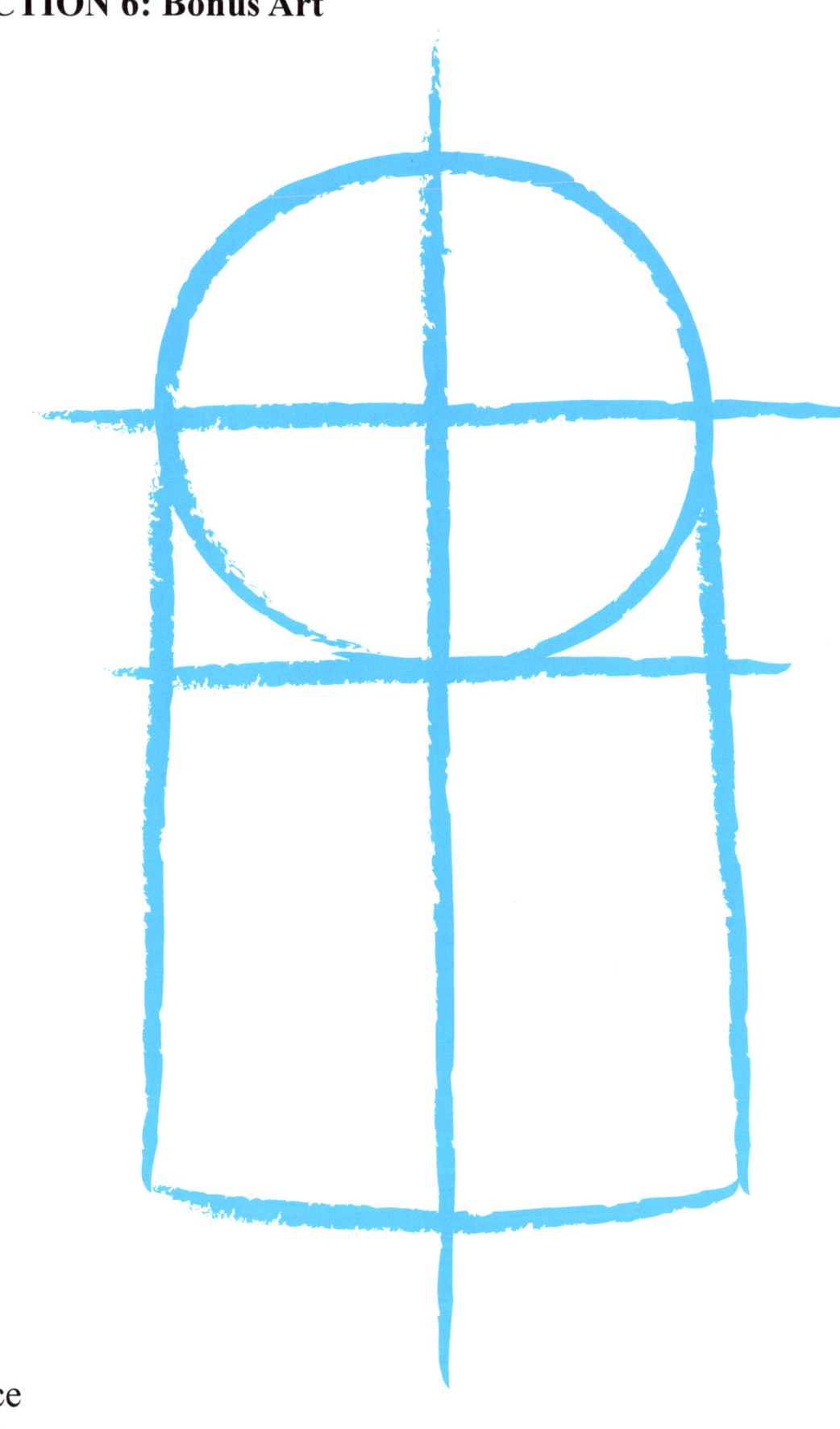

Practice
wire-frame page

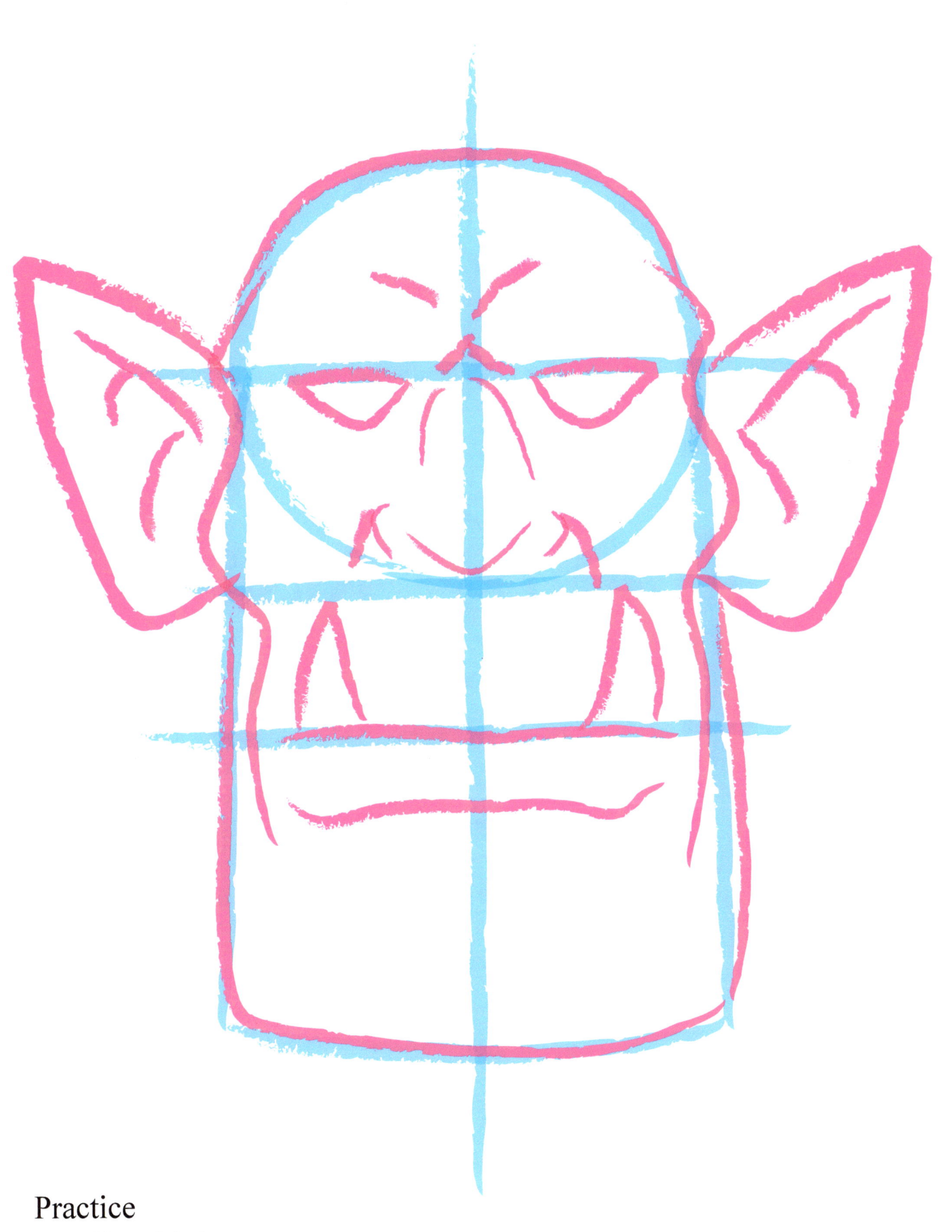

Practice
pencil and ink page

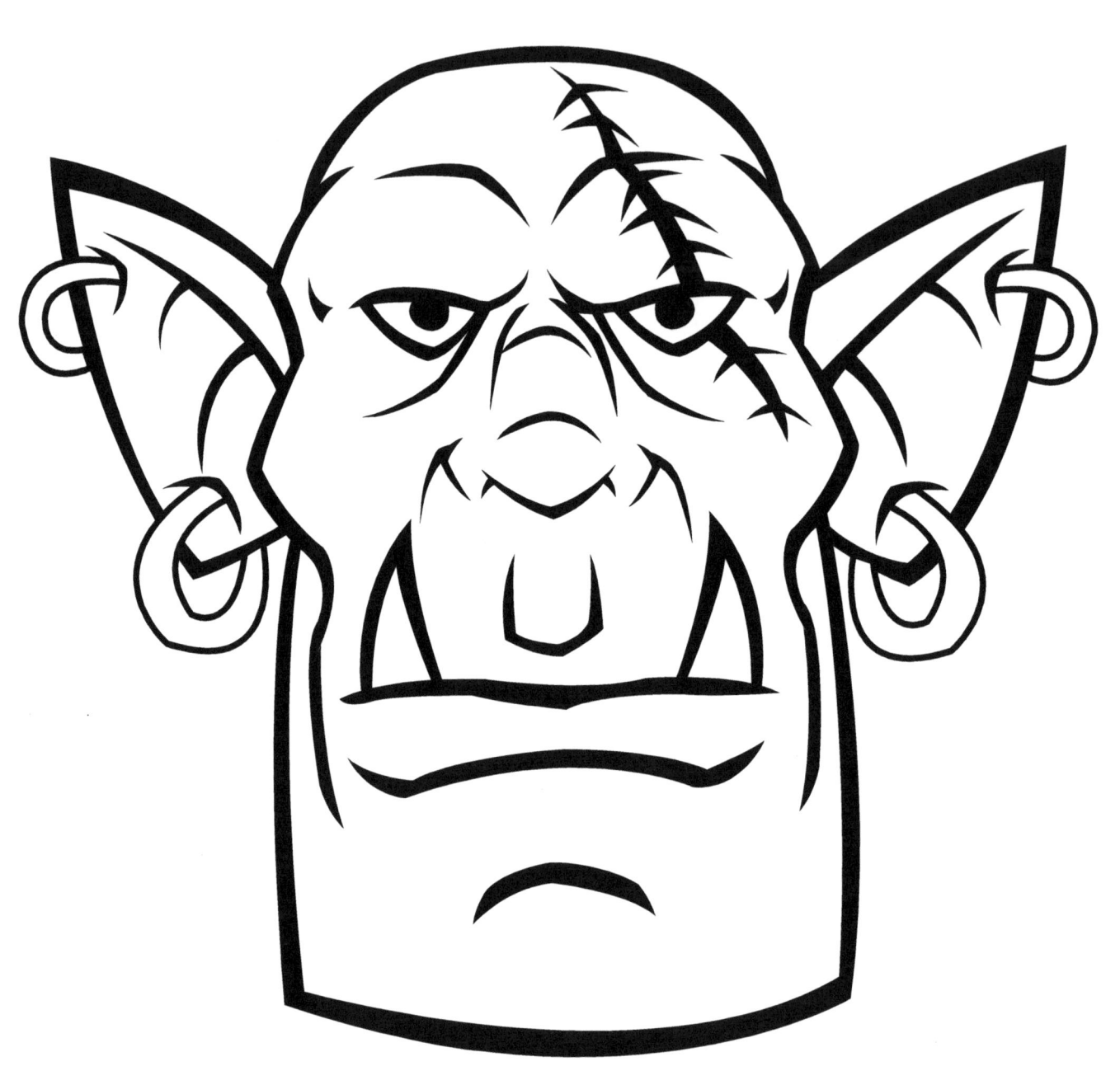

Practice
color page

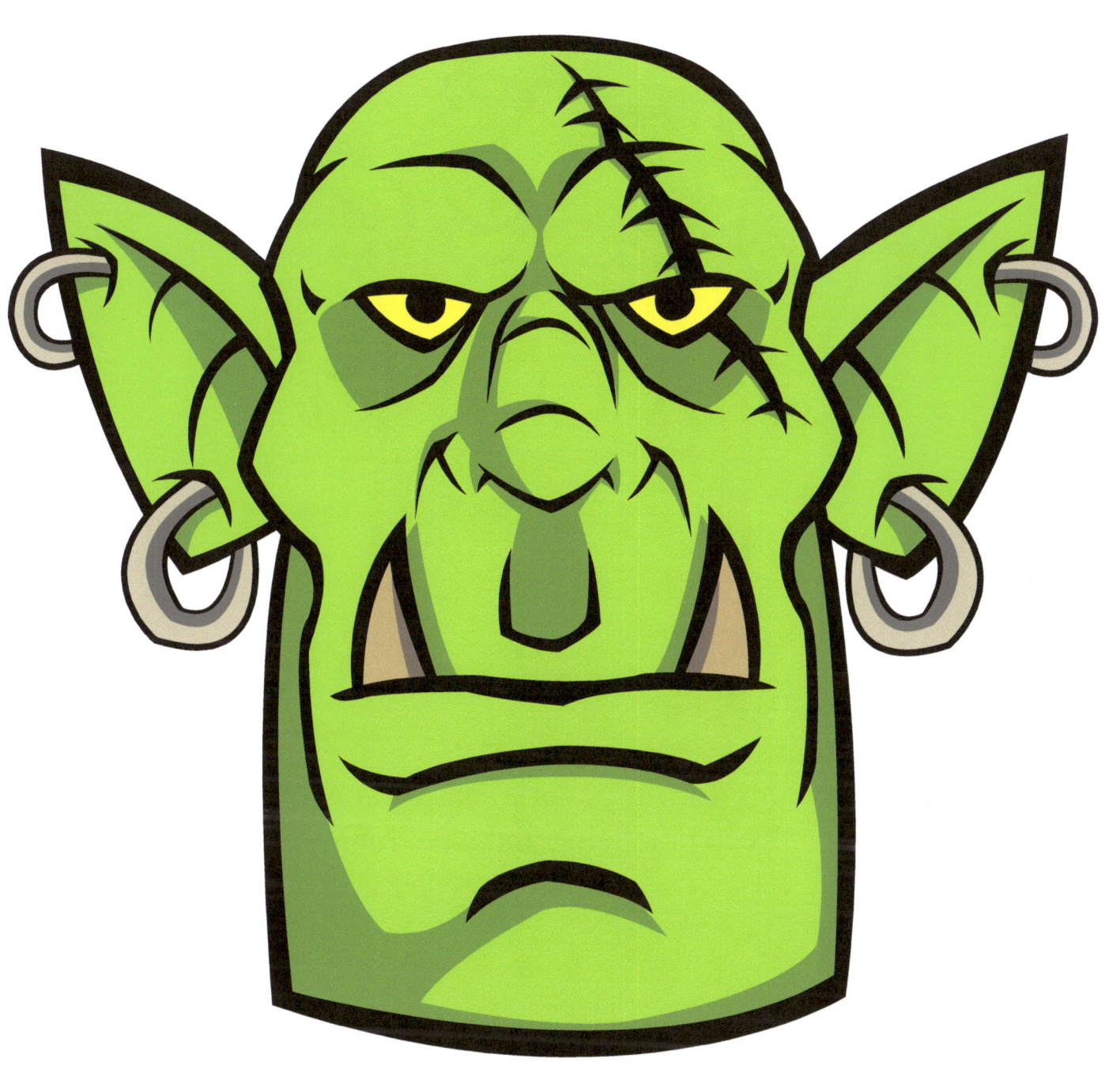

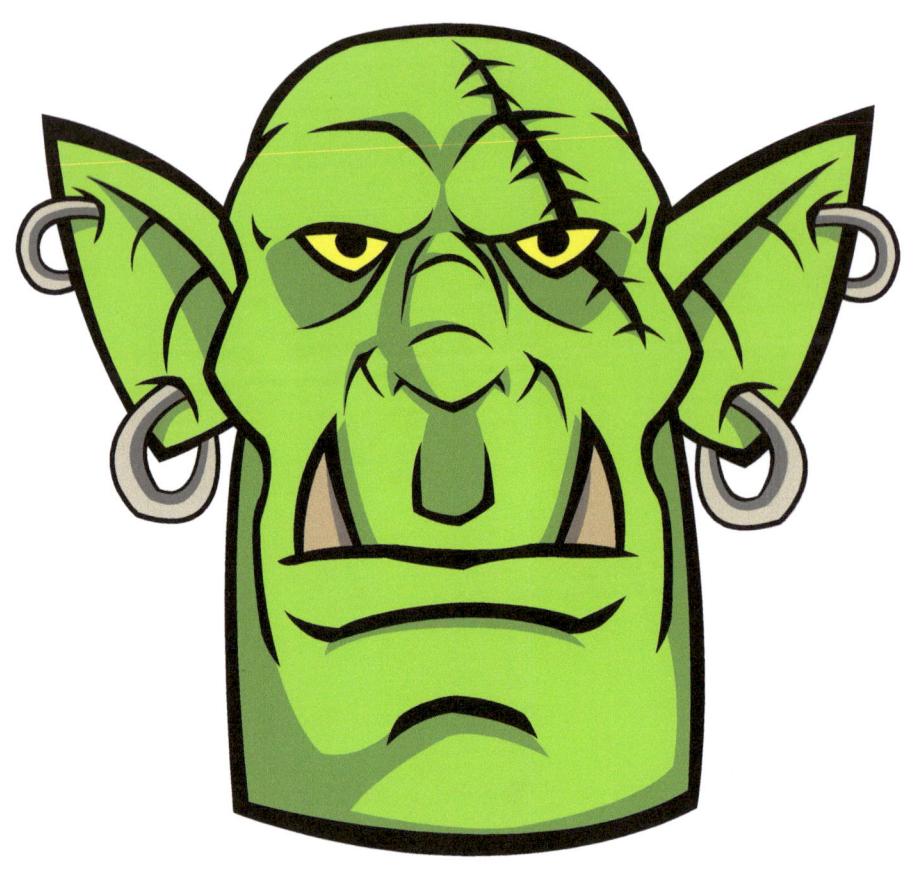

I hope this drawing tutorial has been helpful!
Keep practicing and have fun!

ABOUT THE AUTHOR

My name is Torian Dedmon,sr. and I'm a freelance illustrator
residing in Ca. I taught myself to draw as a child and I've been creating
art ever since! I specialize in traditional and digital illustration.
If you have questions or comments, feel free to contact me!
email: torian@tjdillustration.com
website: www.tjdillustration.com

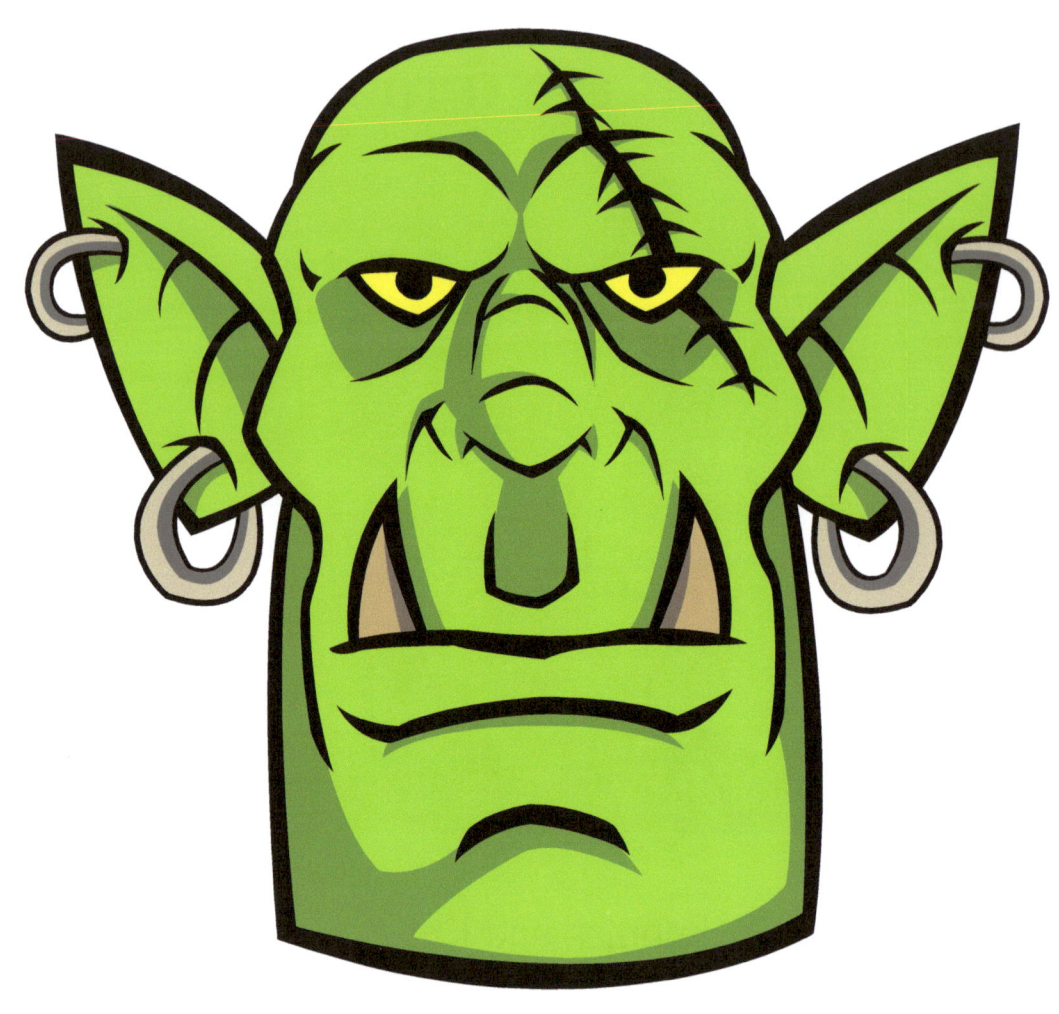

How to draw an Orc!
written and illustrated by Torian Dedmon,sr.
Copyright 2016. All rights reserved.
Published by TJD Creative Media

www.ingramcontent.com/pod-product-compliance
Lightning Source LLC
Chambersburg PA
CBHW050412180526
45159CB00005B/2251